# By Libby Page

Text copyright © Libby Page 2009
Photography copyright © Libby & Sally Page (Unless otherwise stated in acknowledgements) 2009
Design & Layout copyright © Libby Page and Billy Kelly 2009

First published in 2009
Printed and bound in China by C&C Offset Printing

A CIP catalogue record for this book is available from the British Library

ISBN: 978-0-9553779-4-5

For sales contact:
The Manning Partnership
6 The Old Dairy,
Melcombe Road,
Bath, BA2 3LR.
Telephone 0044 (0) 1225 478444
Fax 0044 (0) 1225 478440
E-mail sales@manning-partnership.co.uk
Distribution: Grantham Book Services

Published by Fanahan Books
Evelyn House, Leddington Way, Gillingham, Dorset, SP8 4FF
www.fanahanbooks.com

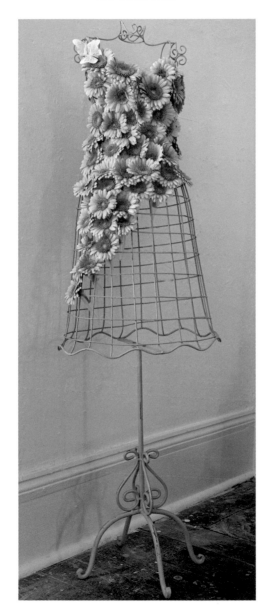

# Introduction

There is just something about pink. From sunsets and melt-in the-mouth marshmallows, to voluptuous pink roses and the dusty pink ribbons of ballet shoes, this is a colour that has captured the world for centuries. No other colour carries the same connotations or means as much to so many people. When compiling this book, I was intrigued how everyone imagined something completely personal when I mentioned pink, and with what affection they talked about the colour. Pink is inoffensive, warm and safe, like milky tea in rose patterned mugs or knitted hot water bottles slipped between soft pink sheets.

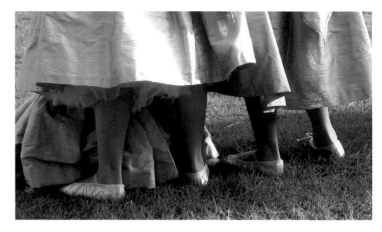

Yet pink can be so many different things; romantic and sensuous when in the form of lace and silk underwear in Chanel scented drawers, or cheerful and pretty when in the shape of cherry blossom trees. From sleepy baby pink to a flamboyant shocking pink, the colour can generate so many different reactions and emotions.

Despite being the obvious colour of femininity, pink is a colour that has been hugely popular in many different spheres. The President of Argentina lives in La Casa Rosada, or The Pink House, and Elvis Presley owned the most famous pink Cadillac in the world. Since pink dyes were discovered there has never really been a period in history when the colour has not been popular, and with many men now beginning to embrace the colour, it seems pink will continue to conquer the hearts of the world.

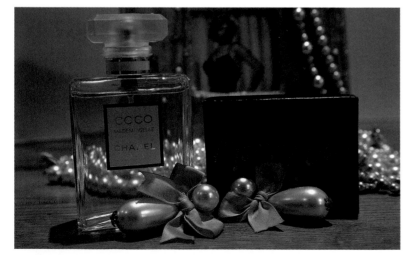

Above all, I think pink is a joyful colour. Who could fail to feel happy when looking at a raspberry pink stiletto or bundles of pink tulips? Whatever images I picture when thinking of the colour pink, and however varied they may be, there is one thing that remains the same; they are always happy images. Mountains of pink dolly mixtures, princess bedrooms, peonies, fuchsia dresses, the surprise of pink within a shell, sparkling pink bubbles in a champagne flute.

Within a woman's life pink evolves but is never lost. A soft pink nursery with blush-coloured blankets changes to a more vibrant pink fairy outfit and dolls in rosy dresses. Pink wellington boots and wax crayons are followed by sequined fuchsia slippers and pink blusher. As a girl becomes a woman pink appears in bouquets of flowers, in underwear and pink shoes, and in that one prized lipstick.

I think few people love any other colour as much as many

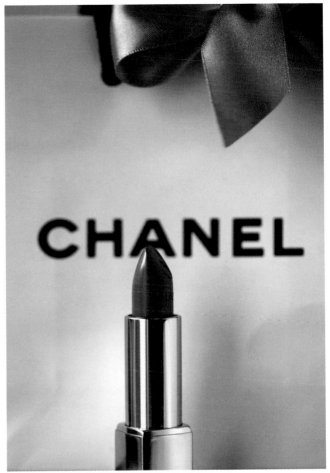

women love pink. This initially started as a project but evolved into a book due to the amazing response I received. Therefore I would like to thank everyone who responded and contributed to this book and hope they enjoy reading it as much as I enjoyed producing it.

The phrase "looking at the world through rose-tinted glasses" really shows how pink can provide a refuge of happiness. I hope that this book will provide a similar escape.

# The Language of Pink

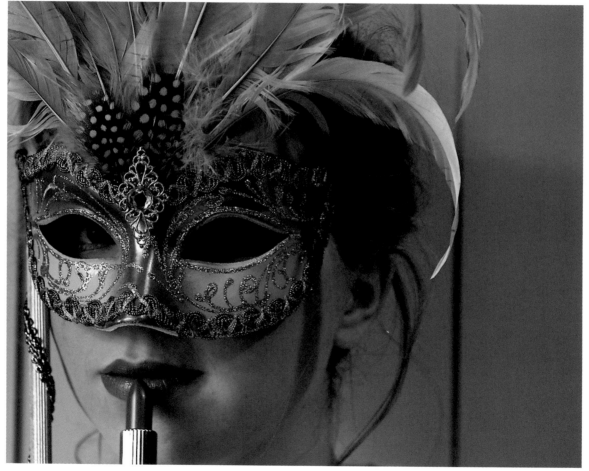

*Tickled Pink* – to be happy

*In the Pink* – to be in good health

*Pink Collar* – the group of jobs traditionally performed by women

Fuzzy Pink, Pink Popsicle

Pink Swoon, Pink Poodle, Cinder Rose

Starlit Pink, Pink Sugar, Pink Ballerina

Sandwashed Pink, Pink Pearl

Colours from Lancome, MAC, Chanel, Bobbi Brown, Clinique, Farrow & Ball

# What is Pink?

What is your favourite pink item? *Old faded silk roses in an old mirrored vase*

What is your favourite shade of pink? *I love all shades from the palest shell pink to neon pink. I love working with fluorescent pink for fashion shows*

If the colour pink was a person, what do you think they would be like? *Soft, sensuous and shy if they were pale pink. Loud, sparky and funny if they were neon*

*Lucinda Chambers*
*Fashion Director Vogue*

# When writing this book I was often struck by the question: What is pink? When does a mauve pink become a lilac, or a raspberry become a red? Are flamingos, those famously pink birds, really pink or are their feathers tinged a more peachy shade? I think it is down to personal opinion; what might be lilac to one person could be dusty pink to another.

Personally, I think pink is characterised by a sweetness of hue, that sugary shade that turns a scarlet red into a deep raspberry pink. Or perhaps the question could be answered in the words of Christina Rossetti: "What is pink? A rose is pink, by the fountain's brink."

**What is your favourite pink item?** *A pink vintage 1930s dress*

**What is your favourite shade of pink?** *Dusty pink*

**What is your favourite pink flower?** *A rose*

*Pearl Lowe*

# The History of Pink

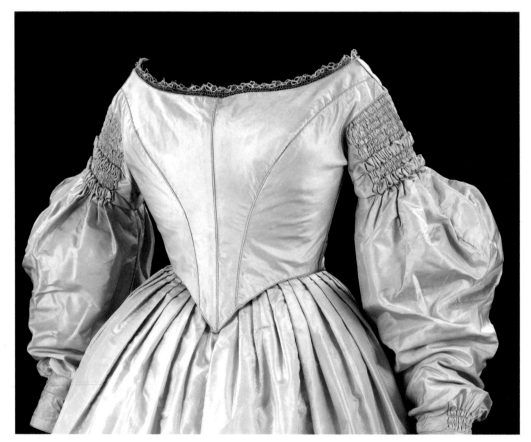

Woman's bodice and skirt made of pink silk trimmed with blonde lace          British, c. 1836

Today, pink can be visible in anything from clothes to shoes, fridges to phones, but, when did our love affair with the colour begin?

Pink dyes originally came from the root of the madder plant which gave a light, delicate shade compared to the more vivid red achieved from cochineal dyes. As red and pink dyes become softened with time and light more quickly than other colours, some of the gentle shell pinks we see today could once have been a much deeper colour.

After the War of the Roses in 1455–1487, the Tudor rose was created combining the red rose of the House of Tudor and the white rose of the House of York. Over time the red and the white merged and the Tudor rose was often shown as a pink flower. This royal rose can be seen on some of Elizabeth I's dresses.

Pink was also popular during Elizabeth's reign due to heavily scented carnations being introduced into gardens around this time. As a result, this carnation pink became very fashionable and is the flesh-pink tone that Elizabethan portrait painters often used as a background wash.

Man's waistcoat shape, tamboured in ivory ribbed silk
French, 1750s

Pink has not always been a colour associated with femininity. From the 1750s, red was the colour of the English army, therefore pink was adopted for boys as a paler, younger form of this strong colour.

Particularly in European countries, where a huge value was placed on flowers, pink appeared as a natural floral colour on men's garments, such as the waistcoat pattern above – the flowers representing wealth and status.

The "blue for boys and pink for girls" tradition is a relatively modern concept. Before the 18th Century there was no real gender distinction between colours, as children were "seen and not heard" and had no real public role. They therefore wore white dresses until around the age of five, regardless of sex. It was only in the 20th Century that pink became the distinct colour for little girls.

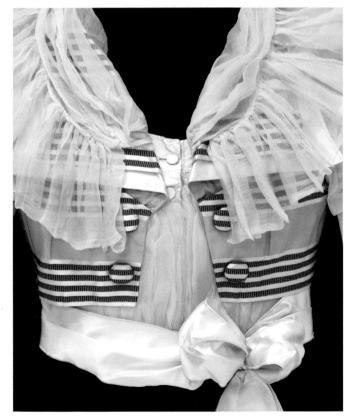

Woman's bodice made of silk with an integrated ribbon stripe, trimmed with silk chiffon and lined with silk and whalebone strips
Worth. Paris, 1890-93

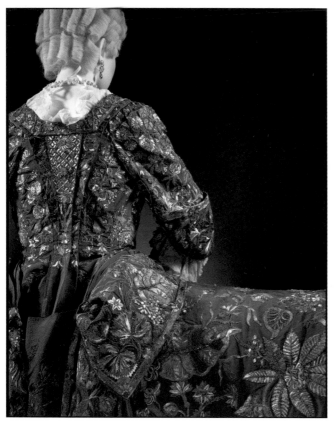

Throughout the late 16th and early 17th Centuries varying shades of pink were popular, and their names can be seen in household inventories of the time. Lusty Gallant was a pale red verging on pink, and Lady's Blush or Maiden's Blush described a more delicate pink.

Another shade of pink was named Rose Pompadour in the 18th Century, after Madame de Pompadour. Louis XV's mistress, and an important figure in fashion and society, Madame de Pompadour became involved in the development of Sevres china. She was also famous for her love of the colour pink, and the colour Rose Pompadour was introduced into the china in 1757. This shade of pink became adopted for clothes as well, such as the waistcoat that is shown on the right.

Above: Mantua and petticoat of silk embroidered with silver thread            English, 1740–45

Opposite page: Woman's silk waistcoat embroidered with silver-gilt thread and sequins            English, 1760s

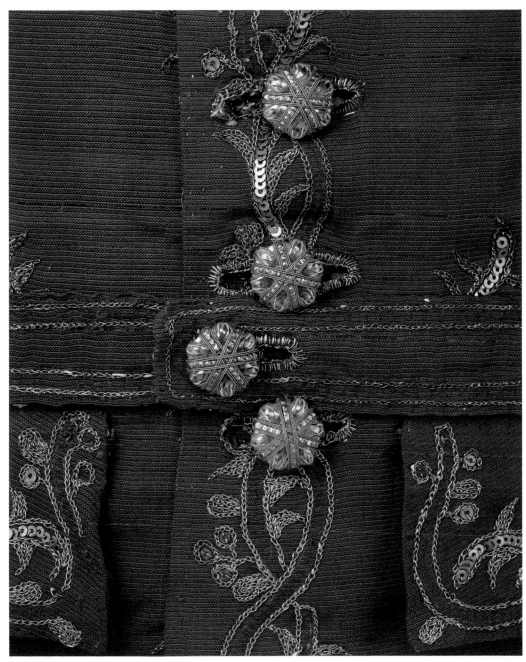

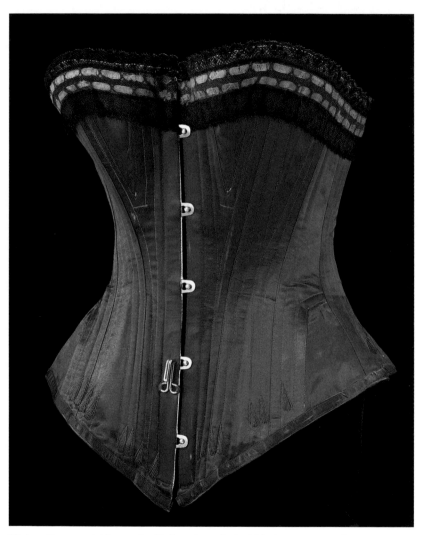

Pink satin corset trimmed with hand-made bobbin lace     British, 1890s

By the 1850s coal tar aniline dyes had been discovered, revolutionising the palette of colours achievable for fabrics.

With the discovery of these artificial dyes more intense fuchsias and magentas were achieved, such as in this mouth-watering corset from 1890.

To me this corset really shows the transition of the colour pink in history from a subtle tone popular with both men and women, to something romantic, luscious and highly feminine.

**What is your favourite pink item?** *Salmon pink cropped trousers*

**If the colour pink was a place, what place would it be?** *Petra – "A rose red city half as old as time"*

**What would the colour pink smell like?** *My father's rose garden*

*Susan North*
*Curator of 17th & 18th*
*Century Fashion & Textiles*
*V&A Museum*

# Marilyn Monroe

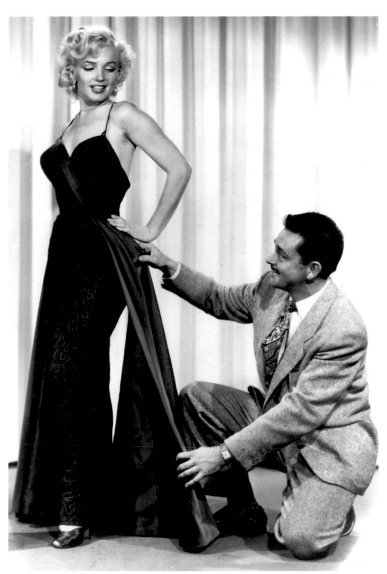

**Few people** embody the colour pink more than Marilyn Monroe. The epitome of femininity she is one of the first women I think of when imagining the colour. If pink had a sound, perhaps Marilyn Monroe's vivacious laughter would be it.

Yet, whereas Monroe herself has gone down in history, the man who dressed her for eight of her films, as well as designing many of her personal outfits and becoming her close friend, is a relatively unknown star.

Not only did William Travilla design for his famous muse Marilyn Monroe, but he also dressed Hollywood stars from Joan Crawford to Jane Russell and Judy Garland. He has an Oscar and several Emmys to his name, including one received for his work designing the costumes for the Dallas TV series. In addition to designing for Marilyn Monroe (and the entire cast of her films) he ran a thriving couture business and became an integral part of the Hollywood fashion scene.

Walking among some of Travilla's dresses at an exhibition in the Fashion Museum in Bath, it was awe-inspiring to think that many of them were stitched as Marilyn Monroe stood in them. Although Monroe herself may no longer be with us, these dresses remain in her exact shape with traces of her life still very visible.

One of the dresses in the collection was borrowed by Marilyn Monroe, worn once and left in a bag until it was rediscovered for the exhibition. It has tyre prints on the side and a lipstick mark on the hem.

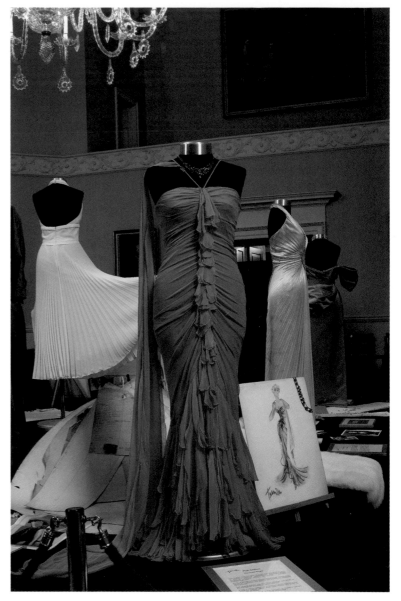

Photographed at the Fashion Museum in Bath during the recent Travilla exhibition. Dresses on loan from the Travilla Estate

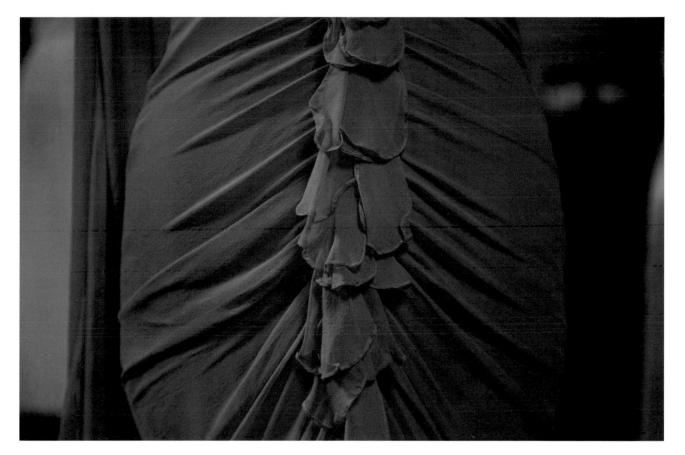

# Shocking *Pink*

My favourite dress in the exhibition was this shocking pink chiffon evening gown that was made for one of Marilyn Monroe's personal appearances. The ruffles down the centre remind me of the open mouths of wild foxgloves.

The dress contains a clever hidden zip at the front, which maintains the ruched effect, and wire around the base to keep its shape. There is also boning in the waist and at the back of the dress.

I think the softly hugging fabric of this dress must really have emphasised Marilyn Monroe's fabulous and famous curves. I was fascinated to hear that, based on Travilla's original patterns for Marilyn Monroe, her measurements were: 34", 22", 36".

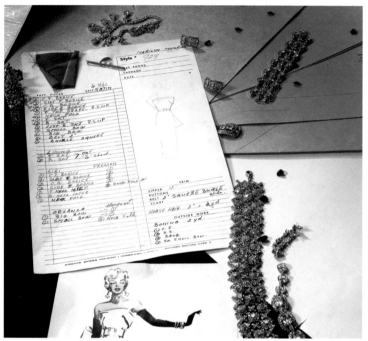

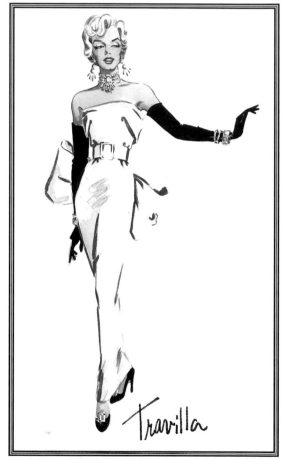

William Travilla also produced exquisite sketches as well as dresses, and on each sketch he drew the face of the person his design was intended for. Here Marilyn Monroe can be seen in Travilla's design for the pink dress she wore to sing Diamonds are a Girl's Best Friend.

Each time Travilla designed costumes for a film, he would make several versions, many of which were simply thrown away after the filming finished.

Above are Travilla's notes on the developed design and copies of the patterns for the dress.

This candy pink dress was a prototype for the dress Marilyn Monroe wore to sing Diamonds are a Girl's Best Friend. The bow has horse hair and ostrich feathers inside to hold its rigid shape and the dress itself is lined with the green felt from a billiard table to give it the right shape and movement.

It is amazing to think that Marilyn Monroe performed the scene wearing such a heavy and architectural dress, yet appeared in no way encumbered.

"I took a brilliant candy pink silk peau d'ange and flattened that to a green billiard felt. Apart from the two side seams, the dress was folded into shape, rather like cardboard. Any other girl would have looked like she was wearing cardboard, but on the screen I swear you would have thought Marilyn had on a thin piece of silk. Her body was so fabulous it still came through."

*William Travilla*

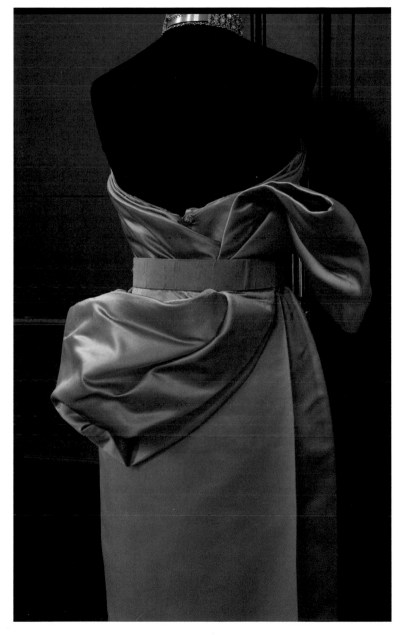

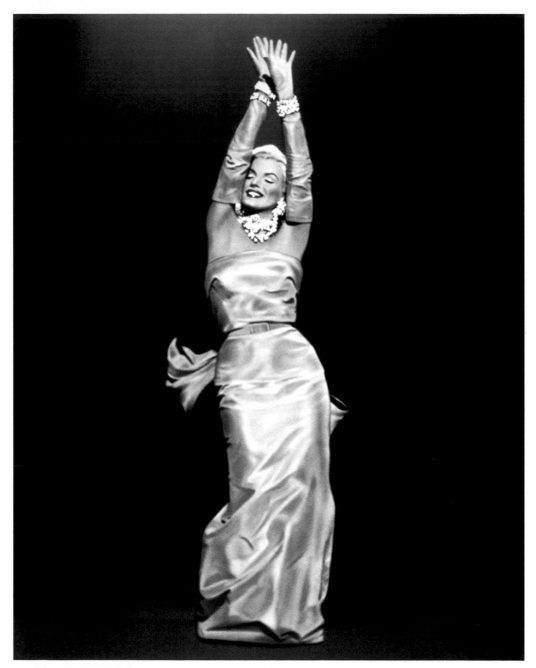

# Pink Diamonds are a girl's best friend...

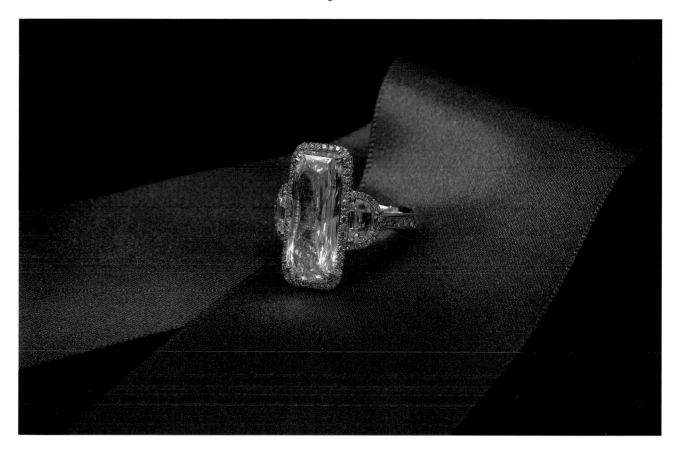

This £450,000 pink diamond ring captures what I believe is many women's most fanciful and gorgeous dream. Exquisite beauty and unattainable luxury seem to be embedded in the glittering stones.

No one really knows where pink diamonds get their colour from, although some suggest it is to do with an anomaly in the carbon structure.

Pink diamonds are classified by their shade, from soft Blush Pink to Orchid Pink and Vivid Pink.

When the manager of Asprey's suggested that I try this ring on, I felt weak at the knees. The platinum band slipped smoothly on and the huge pink diamond sparkled happily on my finger. When I looked down at my now beautiful hand the ring seemed to wink seductively in the light.

Glistening, tactile and deliciously pink; I am now irrevocably convinced that pink diamonds really are a girl's best friend.

# Vintage *Pink*

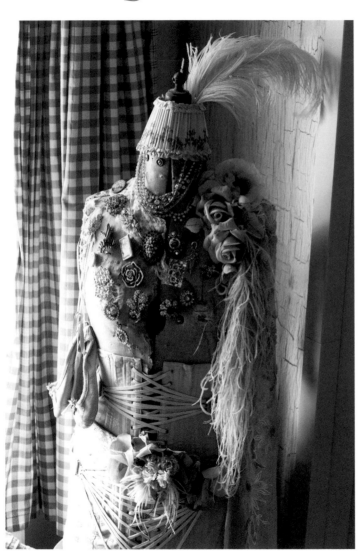

Vintage dusty pinks seem all the more desirable because they have been faded by love and time.

An avid collector of old textiles, accessories and homeware, Niki Fretwell has filled her life with everything vintage and runs a small business called Nostalgia at the Stone House.

These photos show a tiny portion of Niki's extensive and well-loved collection, ranging from vintage shoes, fabrics and floral quilts to pretty china, French boudoir accessories and Victorian postcards.

**What is your favourite pink item?** *A vintage Versace bag with pink rhinestones*

**What is your favourite pink flower?** *Rose or Bougainvillea*

**What would the colour pink smell like?** *Sweet pink sugared elephants!*

*Rebecca Lowthorpe*
*Fashion Features Director Elle*

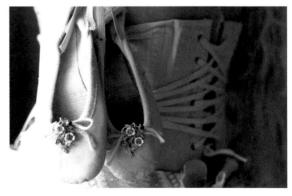

Some of Niki's favourite treasures are these fabulous 1940's floral hats.

As well as sourcing collectables from jumble sales and flea markets Niki also makes her own creations, such as patchwork cushions sewn from salvaged scraps of antique and vintage fabrics and lampshades trimmed with old lace and braid.

Perhaps the most popular are the smiling rag dolls she makes; each one dressed in an outfit made from long-forgotten textiles, a co-ordinating jacket and an antique diamanté brooch.

**What is your favourite pink item?** *A very old pink Whistles antique-looking jacket, or an old pink slip I wear on holiday in Ibiza sometimes!*

**What is your favourite shade of pink?** *A blushy rose tone – the colour of vintage slips*

**What would the colour pink smell like?** *Roses – always!*

*Shelly Vella*
*Fashion Director Cosmopolitan*

# Alice Temperley

**Famous for** her hard-working nature, fabulous frocks and loyal fan base, Alice Temperley is a designer to be reckoned with.

After growing up in rural Somerset she attended Central St Martins and graduated with an MA and an award for innovation. More recent awards include the Glamour Magazine Designer of the Year, Elle Young Designer of the Year Award and the Walpole Award for British Design Excellence.

Temperley London, the label Alice Temperley launched with her husband Lars von Bennigsen in 2000, is now sold in over 30 countries. The label consists not only of the beautifully made red carpet dresses Alice Temperley is perhaps best known for, but also tailoring, knits, bridal wear, accessories and the exclusive Black Label collection.

**What is your favourite pink item?** *I love fluorescent pink nails in the height of summer when I have some sun, and I love fuchsia pink knitted dresses in winter – very flattering on lots of skin tones and a nice surprise with all the black*

**What is your favourite shade of pink?** *Fuchsia, the brighter the better*

**If the colour pink was a person what would they be like?** *If it was a coral pink they would be very sexual, quite exotic, confident and happy. If it was fluorescent pink the person would have endless energy and a positive outlook on life but would be more unpredictable.*

**What is your favourite pink flower?** *Bougainvillea*

*Alice Temperley*

# Contemporary *Pink*

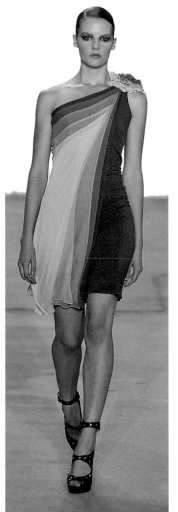

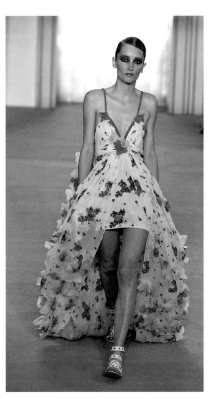

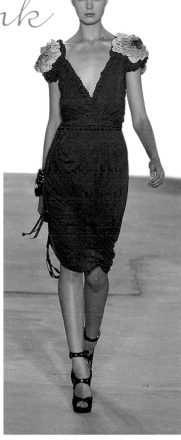

Temperley's Spring 2009 collection was entitled Romantic Odyssey and was inspired by the Age of Enchantment, a period in the 20th Century of decadent and fantastical illustrations in books and annuals.

This style can be seen reflected in the florals, ruffles and classic draping of Temperley's designs.

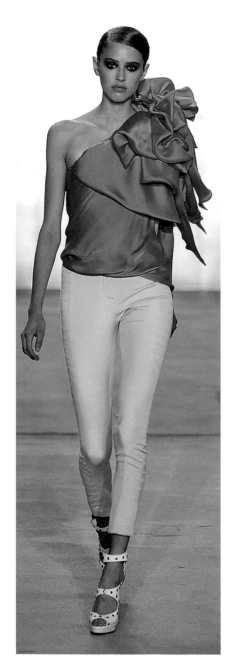

**Alice Temperley** was named one of Britain's top 30 business women, which is hardly surprising considering the success Temperley London has achieved and the dedication she devotes to her work.

Temperley continued to work on her Spring 2009 collection despite being heavily pregnant with her first baby, and vowed to be at the show despite it being only a few days after her baby's due date.

**Not only** are her designs fabulous, but I particularly admire Alice Temperley's philosophy: producing clothes to make women look and feel beautiful, rather than becoming slaves to passing trends.

These innovative designs display the craftsmanship that makes Temperley London such a coveted label, followed by stars such as Keira Knightley, Claudia Schiffer, Julia Roberts, Halle Berry, Mischa Barton and Gwyneth Paltrow.

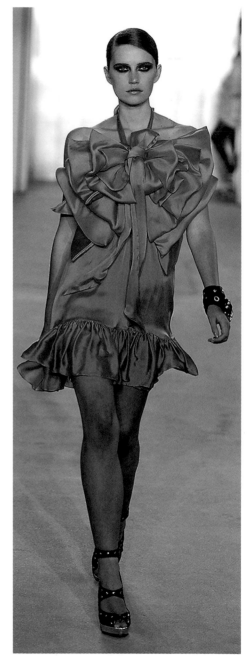

28

# Matthew Williamson

Click on to Matthew Williamson's website and you are greeted by a glow of fuchsia pink. Vivid colours are perhaps his trademark, and his Spring 2009 collection was no exception, as demonstrated by the to-die-for silk jacket and cigarette pants to the right.

Matthew Williamson graduated from Central St Martins with a BA in Fashion Design and Printed Textiles, before working at Marni, Monsoon and Accessorize. In 1997 Matthew Williamson Ltd was born and his debut show saw models Kate Moss, Jade Jagger, Diane Kruger and Helena Christensen taking to the catwalk in the collection entitled Electric Angels.

In 2004 Williamson won the Elle Designer of the Year award, and 2005 saw him win the Moët & Chandon Fashion Tribute and become creative director of Italian fashion house Emilio Pucci. A huge hit with celebrities such as Gwyneth Paltrow, Kate Moss, Kirsten Dunst, Naomi Campbell and Nicole Kidman, Williamson knows the clothes that women want to wear. However with previous lines for Debenhams and a summer collection being launched in collaboration with H&M in May 2009 it is not only the rich and famous who can lap up his fairytale designs.

With a flagship store opening in New York and plans to introduce a menswear line, Matthew Williamson continues to spread his dreamy prints and neon magic across the world.

**What is your favourite pink item?** *The new pink denim jeans in the Matthew Williamson for H&M menswear collection, launched in May 2009*

**What is your favourite shade of pink?** *Fuchsia Pink!*

*Matthew Williamson*

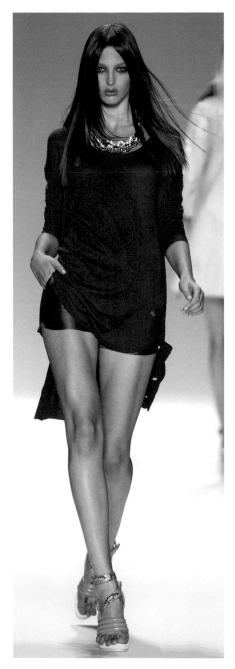

In spring 2009 Williamson launched his first full line of accessories, including covetable handbags, footwear, jewellery, belts and eyewear. The hot pink patent leather sport sac on the opposite page forms part of his collection, and I think I am not alone in dreaming of this bag swinging from my arm, brightening up a rainy day.

Pink can also be seen in Matthew Williamson's shops themselves. The counter at his Bruton Street store is painted fuchsia, the walls washed in a light candy pink, and a mauve pink glass chandelier hangs from the ceiling. The very picture of rose-tinted calm, I believe that is how every shopping experience should be; relaxed, serene and very pink.

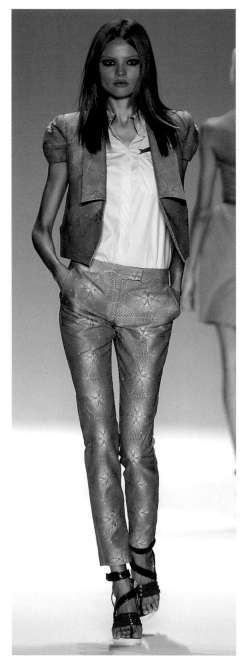

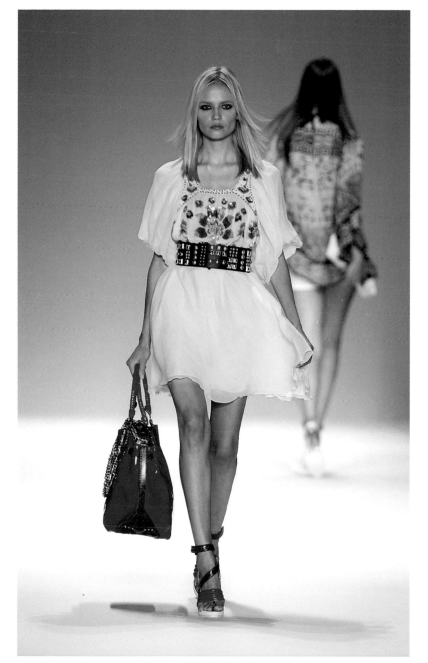

# Shop *Pink*

**Many shops** adopt pink for their bags, logos and interiors as an iconic sign of femininity. Paul Smith's Pink + shop in Tokyo stocks his women's wear and accessories, and is decorated in a stylish pink. However, pink isn't just for girls. The Little Pink Shop in Croyde, Devon, is a surfwear and board stockist for beach babes and rugged surfers alike.

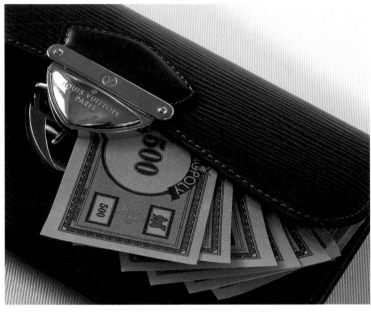

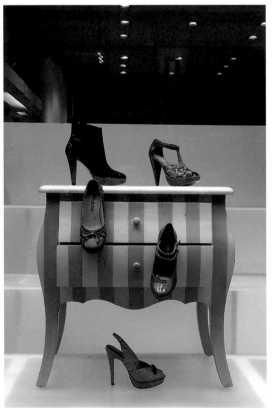

**What is your favourite pink item?** *A hot pink patent Lanvin stiletto*

**What is your favourite shade of pink?** *Hot pink*

**What is your favourite pink-coloured food?** *The pink French Fancy by Mr Kipling!*

*Lucy Yeomans*
*Editor Harper's Bazaar*

"I was shown around Tutankhamun's tomb in the 1920s. I saw all this wonderful pink on the walls and the artefacts. I was so impressed that I vowed to wear it for the rest of my life."

*Barbara Cartland*

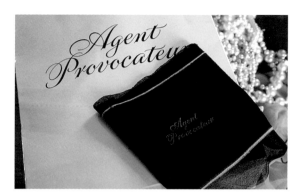

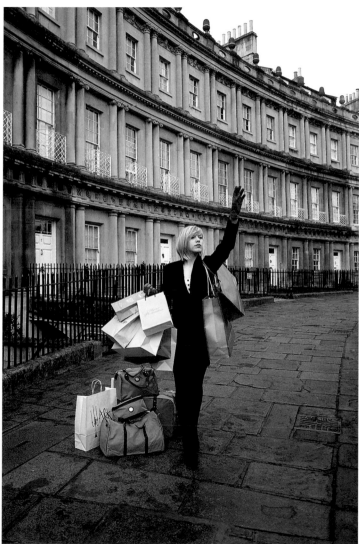

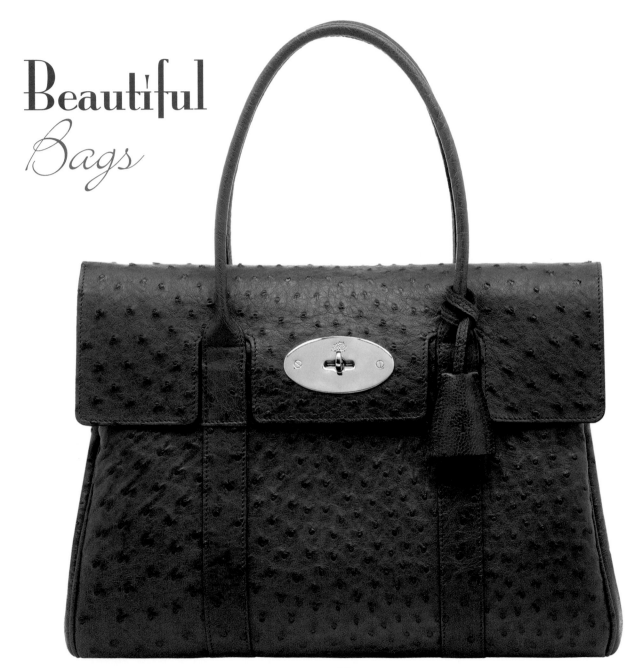

# Beautiful
## Bags

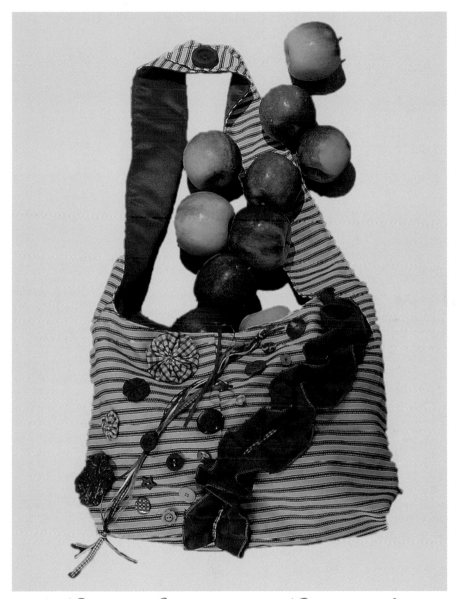

A Pink Bag for a Pink Lady

# Cinderella
## Shoes

Shoe enthusiast Carrie Bradshaw, star of Sex and the City realised during one episode that she had spent $40,000 on shoes so couldn't afford an apartment. The most expensive pair of pink shoes listed in the Forbes top 10 were a $1,000 pair of pink Escada sandals. However that seems a bargain compared to Harry Winston's ruby red Dorothy shoes which had a sparkling $3 million price tag.

# Fancy Frills

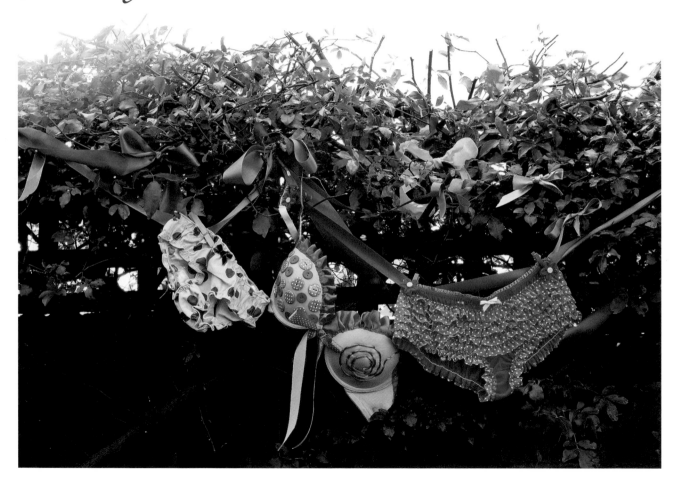

One of the first shops that springs to mind when thinking of underwear has to be Agent Provocateur, whose blush pink bags and packaging show the importance of pink in the world of lingerie.

The American lingerie brand Victoria's Secret has a whole line completely devoted to the colour pink, including pink polka-dot bras and stripy pyjamas.

To me the corset symbolises the ultimate in femininity and luxury. Although it may not have been worn as an everyday undergarment since World War I, when it was abandoned for more functional underwear, it has experienced a resurgence, often as part of an outfit in its own right. Award-winning specialists Eternal Spirits create exquisite, handmade corsets, drawing on historic corsetry techniques whilst also bringing the designs up to date with delectable shades including candy pink and soft rose.

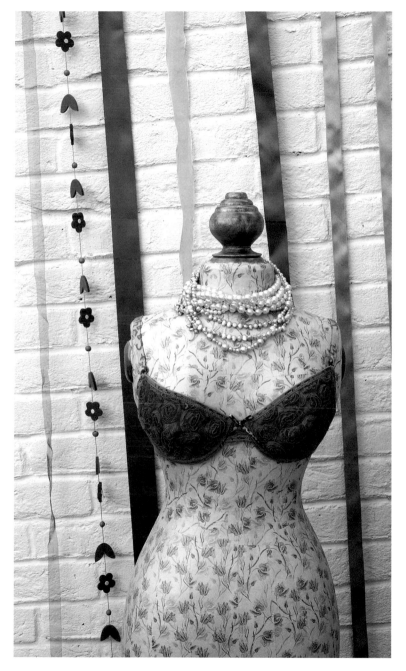

# *Blushing* **Belles**

Pink is a popular colour in the scented world of perfume, from floral or "pink" scents to the pink bottles that encase them.

Lacoste's A Touch of Pink comes packaged in bright pink, where as Calvin Klein's Euphoria Blossom is bottled in frosty pink glass and includes pink peony petals in its soft scent.

The Fragrance Wheel is used by perfumiers to classify scents, and it is split into different colours. Perfumes in the pink section are known as Floral, Soft Floral and Floral Oriental. Common ingredients used in these pink fragrances are rose, jasmine, mimosa, tuberose and, perhaps surprisingly, clove. Orchids are rarely used in perfumes, except when in the form of vanilla pods, which come from the vanilla orchid.

**What is your favourite pink item?** *Hmm...That would be my pink lipstick*

**What is your favourite pink flower?** *A pink hydrangea as it is very English and modern*

**What would the colour pink smell like?** *A gorgeous strawberry tart*

*Jane Packer*

My pink make-up shopping list:
Pink Champagne powder puff (pictured below) from Benefit
Chanel Pink Cloud blusher
Bobbi Brown lip gloss in Pink Blossom
Vera Wang Truly Pink perfume
Barry M neon pink nail varnish

**What is your favourite pink item?**
*A metallic leather tote that I use on the beach*

**What is your favourite shade of pink?** *Dusty Pink*

**What is your favourite pink flower?**
*Peony*

*Anna Bromilow
Fashion Director Tatler*

# Pink Painted Nails

Painted nails have been popular from as early as 3000 BC when the Chinese used a combination of egg whites, beeswax and silver or gold to tint their nails. Another polish they used contained crushed roses and orchids, and gave varying shades of pink and red.

Manicure equipment has been found in the tombs of Egyptians, who also painted their nails. Shades of red were used to denote power, whereas lighter shades were adopted by people of lower rank.

In 1917 Cutex invented the first coloured liquid nail varnish, and a pink shade known as Rose was among their most popular colours, voted one of the three smartest nail colours in 1936.

# Blush Pink

Blusher can be dated back to ancient Egypt when it was worn on the lips as well as the cheeks. Crushed mulberries, strawberries and red beet juice were used in ancient Greece to tint the cheeks and give a healthy looking glow.

The delicate powder blusher that evolved would imply femininity. Yet in Regency England blusher was also worn by men, as pink cheeks suggested strength and well being.

Nowadays blusher comes in varying shades from pale pink to burgundy, and it is usually suggested that the darker your skin tone, the darker shade of blusher you should use. Many make-up artists still draw on the healthy pink notion and suggest rosy shades of blusher to brighten tired skin.

# Buttons & Bows

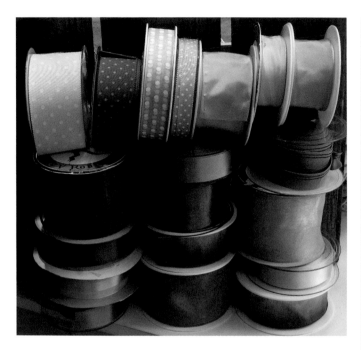

Ribbons are among the oldest form of decoration and have been used since people began creating fabrics. During the 16th Century wearing ribbons was associated with luxury, so much so that the English government tried to ban the wearing of them by anyone not of noble descent.

Using ribbons as extravagant decorations trailing from clothes and accessories became very popular in the 17th Century, and was a trend sported by both men and women.

Nowadays ribbon is used in so many different ways, from craft, to Christmas, to fashion. In 1990 V.V. Rouleaux was launched, and since then has been supplying fashion designers and the public alike with exquisite ribbon and trimmings.

Another ribbon enthusiast is Loulou Loves You, who sells huge handmade silk bows that can be worn in the hair, as bow ties or as brooches, and arrive gift-wrapped with a flourish of pink ribbon.

# *Aladdin's* Cave

Boiled sweets and shards of pink ice spring to mind when I see these gorgeous beads. They look truly edible. Much like their mouth-watering appearance the pink beads have delicious names: Marshmallow Pillow, Dusty Pink Twist, Pearl Rose, Pink Whirl, Dusty Pink Rice and my personal favourite, Icecream Facet.

The beads come from the beautiful shop, Bijoux Beads, where I am lucky enough to have a Saturday job. Each week I can't resist delving my fingers into the trays of beads and it is always the pink ones that I am drawn to first.

In the shop the pink beads and jewellery are always popular, the best-selling combinations perhaps being pink and green, dusty pinks with browns and golds, or the classic fuchsia and black.

Rose quartz is said to be the stone of the heart, and symbolises love and warmth.

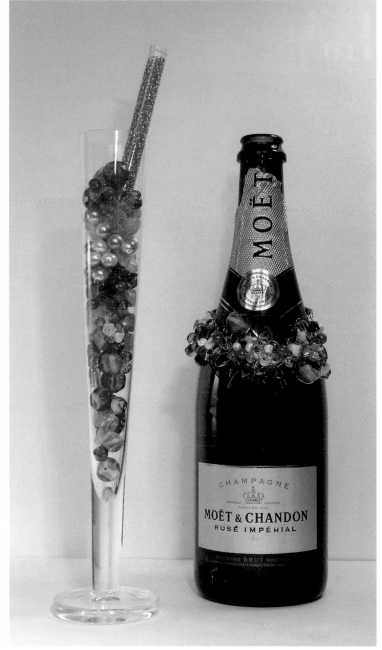

**What is your favourite pink item?** *A pink vest from Reiss*

**What is your favourite pink flower?** *Peonies*

**What would the colour pink smell like?** *Strawberry milkshake!*

*Lorraine Candy*
*Editor in Chief Elle*

# Indian *Pink*

## Surrounded by piles of exquisite pink fabric

scattered with sequins and embroidery, Sunita Patel shows me how to put on a sari and tells me about the importance of the colour pink in India.

Sunita runs a business visiting local schools and teaching the children about Indian culture and the Hindu religion. She is also known locally for her wonderful Indian cooking.

I learn that whereas other colours come and go in Indian fashion, pink is always present, particularly the vivid shades that she loves.

In some regions of India pink is the preferred bridal colour, and it also appears in Holi, the Festival of Colours. People throw water and powder paint at each other in the streets, and often become covered in splatters of pinks and reds.

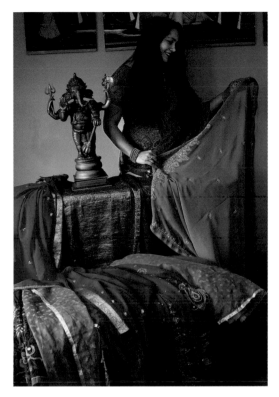

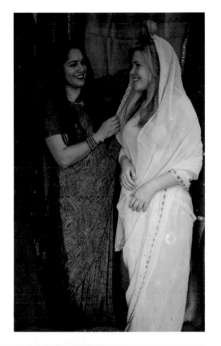

What is your favourite pink item? *A huge pink gauze flower brooch given to me by Anita Pallenberg*

What is your favourite pink flower? *The dog rose in wild hedgerows*

What is your favourite shade of pink? *Indian Pink: the very strong clear colour that Indian women wear and look so beautiful in*

*Joanna Lumley*

What is your favourite pink item? *These beautiful pink saris*

What is your favourite pink flower? *Orchids or Lupins*

What is your favourite shade of pink? *Strong, vivid pinks*

*Sunita Patel*
*A Taste of India*

# Sweet Dreams

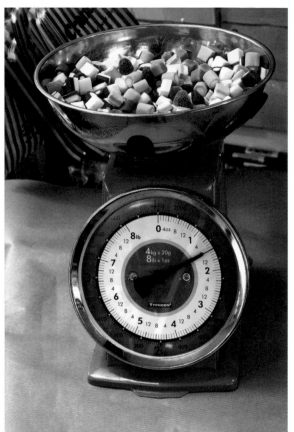

*Do you pick the pink sweet first?*

Last night I dreamt of candy canes,
Of woods with sugared trees,
Flowers made of bubblegum
And liquorice striped bees.

There was a cave of jelly beans,
And a dolly mixture house,
I met the wine gum king and queen
And a friendly sugar mouse.

I sailed on waves of fizzy laces,
I danced in the sherbet rain,
I scaled the pear drop mountain,
And I climbed back down again.

The sun shone on marshmallow clouds,
The air was soft and sweet,
Never again will I see such scenes,
Or have so much to eat.

**What is your favourite pink item?**
*A vintage pink full 1950s skirt with tassels I bought at Alfie's Antiques*

**What is your favourite shade of pink?** *Pale, almost nude skin colour*

**What is your favourite pink-coloured food?** *Marshmallows!*

*Pippa Holt*
*Fashion Features Associate*
*Vogue*

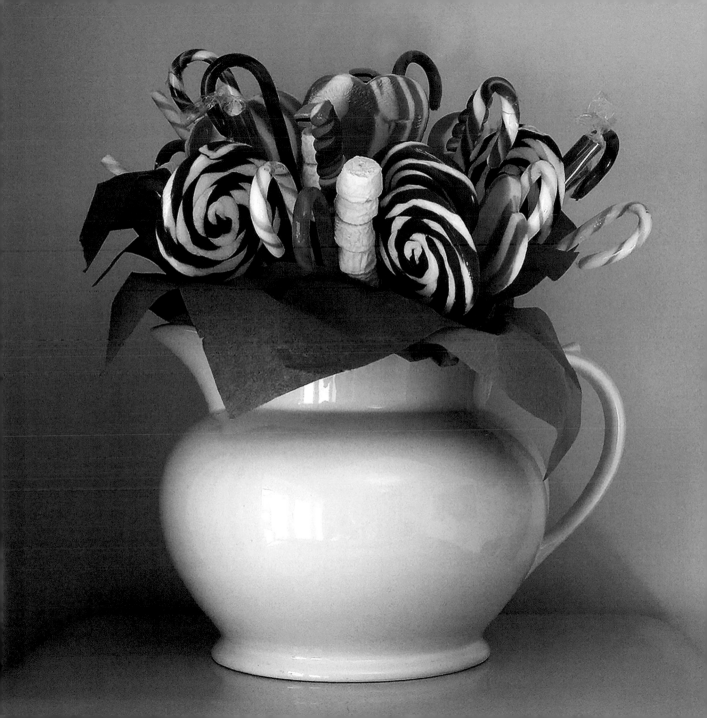

# In the Rose Garden

Evocative of the perfect English summer; pink lemonade, summer fetes and picnics under willow trees, it is no surprise that pink roses are well loved by many people.

BBC TV viewers voted their favourite rose as Gertrude Jekyll, a rose bred by David Austin, which has a rich glowing pink bloom and a strong old rose fragrance.

**What is your favourite pink item?** *A pink handbag, and pink china teacups and saucers*

**What is your favourite shade of pink?** *Rose pink*

**What is your favourite pink flower?** *Peony*

*Deborah Barker*
*Editor Homes & Gardens*

**What is your favourite pink flower?** *The rose (obviously!) Either Gentle Hermione, which is a soft pink, or Strawberry Hill, a strawberry pink*

**What would the colour pink smell like?** *The classic Old Rose fragrance*

**What is the favourite pink item?** *The pink rose hedges in my private garden – I have four of them*

*David Austin*

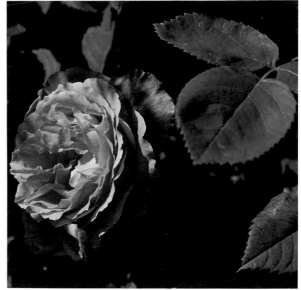

"I think it has been left alone so long – that it has grown all into a lovely tangle. I think the roses have climbed and climbed and climbed until they hang from the branches and walls and creep over the ground – almost like a strange grey mist. Some of them have died, but many are alive, and when the summer comes there will be curtains and fountains of roses."

*The Secret Garden*
*Frances Hodgson Burnett*

# Fairies *at the Bottom of the Garden*

**Once upon a time** in a garden as wide as an ocean, where roses bloomed and hummingbirds flitted through the fragrant air, there lived a fairy king and queen. Their names were King Swallowtwig and Queen Lilybutter and they lived in a castle suspended in the forest canopy.

King Swallowtwig and Queen Lilybutter were good rulers; they visited the bumblebees and brought gifts of pollen, they made sure the dragonflies never went hungry and that all the insects found warm homes in the garden. They themselves were happy in each other's company and lived contentedly in their sunflower carpeted, toadstool-filled castle.

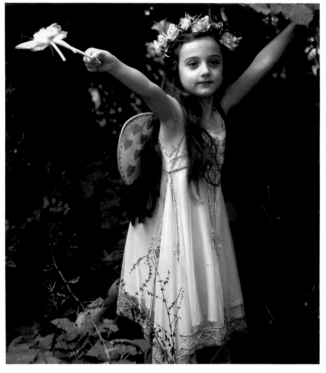

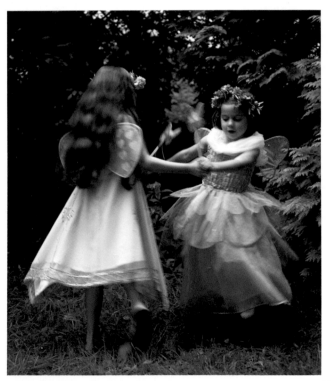

Yet secretly, they both felt that something was missing. They never talked about it, but each of them knew that there was an empty space in their heart – an empty space that seemed deeper and deeper as they grew older.

Every year the king and queen attended the Frog Ball, a highly anticipated event where all their subjects became drunk on dew drops and then danced until the sun rose.

It was the fairy fashion event of the year, and Queen Lilybutter was dressed in a ballgown spun by the very best spiders, with a crown made from sun rays balancing on her flowing black hair.

**The ball** was in full swing as Queen Lilybutter sat on her throne and watched the festivities below. The cricket orchestra chirruped into the cool night air as frogs waltzed beneath the stars and the gossamer wings of the fairies shone in the moonlight.

Queen Lilybutter smiled and breathed in the sweet smell of sugared violets and roasting acorns that drifted from the fairy food stalls near the lake. Nothing seemed out of place, yet somehow Queen Lilybutter felt a growing sense that something was wrong. Her husband must have felt it too, because he suddenly reached for her hand and squeezed it tightly. Amid the laughter and cricket music, the king and queen could make out another sound. Someone was crying.

"This way," Queen Lilybutter whispered, and the two rose and flew quickly to a nearby tree, where the crying seemed to bubble from the very branches. When they touched the ground, the queen noticed two small packages nestled in a pile of fallen leaves, which she hastened to at once. With a gasp and shaking hands, she pulled back the edges to reveal eyes, two noses, two pairs of lips…

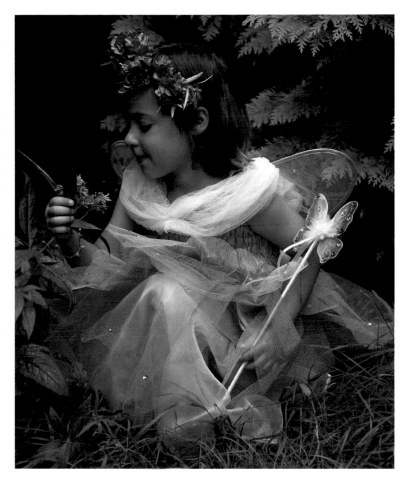

"Babies!" she exclaimed. For they were indeed two fairy babies, abandoned beside the tree. The queen looked at her husband, and in an instant they felt the spaces in their hearts replaced with a joy that felt like flying through an empty sky at dawn or being tickled by another fairy's wings. Queen Lilybutter reached out a hand and touched the baby fairies' soft cheeks.

As soon as she did so a huge rat scuttled out from behind the tree, cackling and baring its yellow teeth. "These orphan fairies do not belong to you. I stole them myself, and would not sell them, not unless it was for the whole of the fairy kingdom."

The king and queen looked at each other; not their thrones, nor castle, not even their fairy toadstools which they so loved to dance beneath, amounted to the price of the sudden love they felt for the two orphans. So in an instant King Swallowtwig and Queen Lilybutter gave up their beautiful fairyland in exchange for the two baby fairies, rescuing them from the evil rat. Together they escaped into the human world where they remained, living in blackberry hedges at the bottom of gardens, unnoticed by prying human eyes. But listen hard enough on the evening of the annual Frog Ball, and you will hear them dancing with their Molly and May, four hearts full to the brim as they waltz beneath the stars.

# Pink Tinged Petals

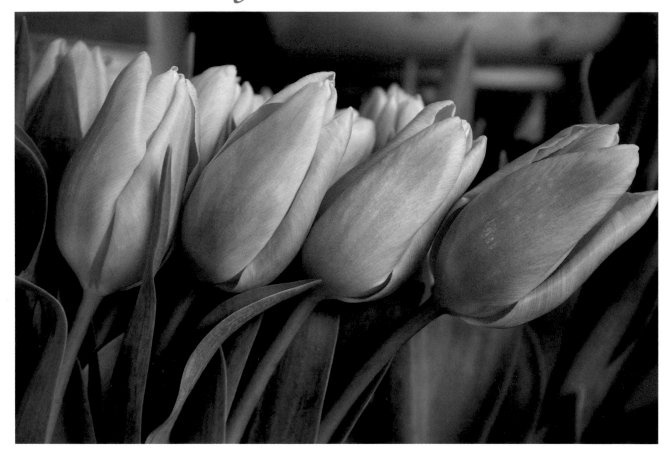

## The Meaning of Pink Flowers

Pink Tulip - **Caring**    Pink Rose - **Friendship**    Pink Carnation - **Gratitude**

Pink Peony - **Bashfulness**    Pink - **Boldness**    Pink Convolvulus - **Tender affection**

**What is your favourite pink item?** *My pretty pink ballerina ballet pumps*

**What is your favourite shade of pink?** *Fuchsia*

**What is your favourite pink flower?** *A rose*

*Louise Court*
*Editor Cosmopolitan*

59

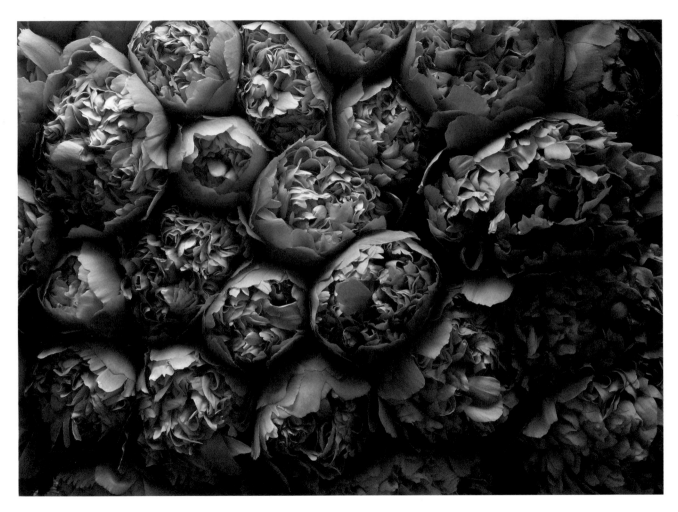

"I do like a flower that looks like a pudding ..."
*Fiona Oliver, Chef*

# Cupcake Heaven

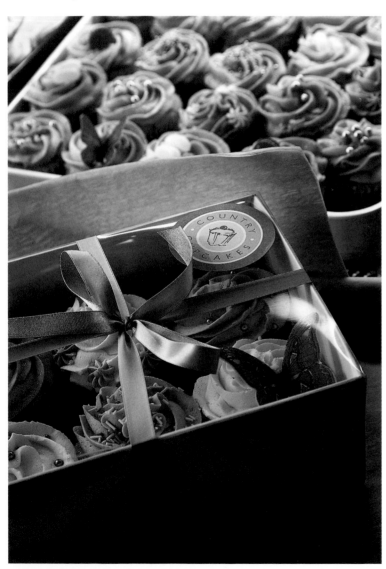

## Libby's Pink Cupcake Recipe

Ingredients:
110g/4 oz self-raising flour
110g/4 oz butter
110g/4 oz caster sugar
2 eggs
Splash of milk
Drop of pink food colouring
3 tablespoons of raspberry jam

1) Preheat oven to 160C/325F/Gas mark 3. Line a 12-hole cupcake tray with paper cases (preferably pink!)

2) Sieve flour into large bowl. Add the butter, sugar, eggs and milk and mix with an electric mixer until smooth.

3) Split the mixture evenly into two bowls. To one bowl mix in a drop of pink food colouring.

4) Using a teaspoon fill the cupcake cases with half plain mixture, half pink mixture.

5) Add a blob of raspberry jam to each case and use a skewer to create a swirly pattern in the mixture.

6) Bake for 20 minutes. If the cakes are golden and spring back when you poke them, remove from oven, if not, leave for another 5–10 minutes.

7) Leave to cool on a wire cooling tray, and then decorate with pink butter icing and dolly mixtures.

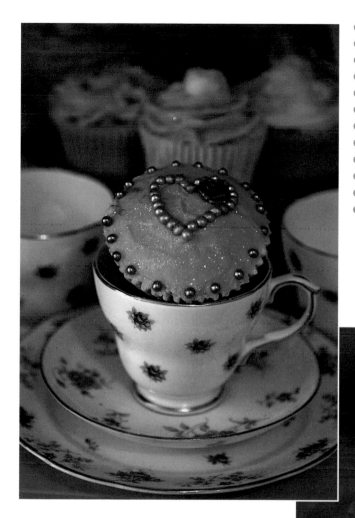

Apparently, sweet pastries and cakes taste their most delicious when presented in pink boxes or served on pink plates, as the sweetness of pink makes us crave sugar.

63

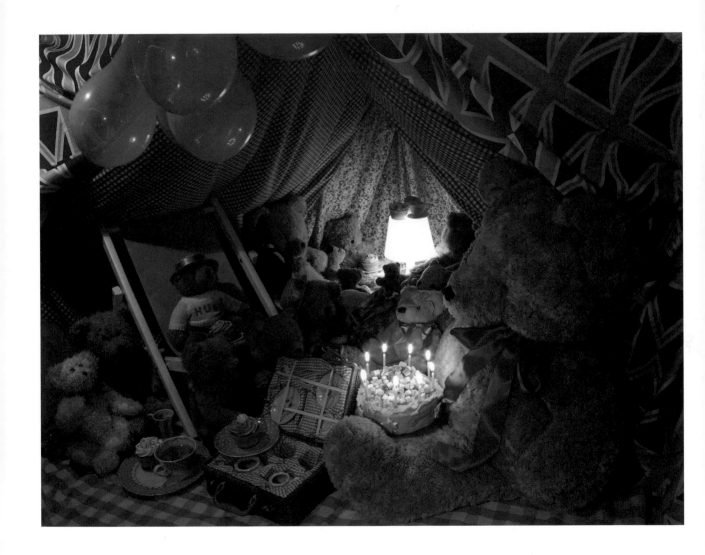

# Baby *Pink*

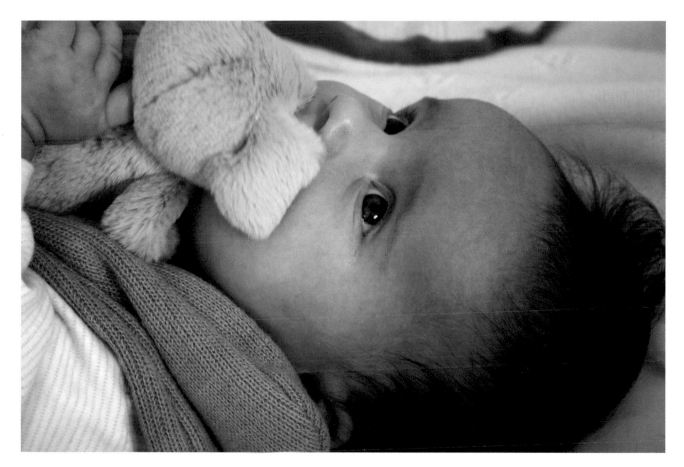

"Go to sleep and good night;
In a rosy twilight,
With the moon overhead
Snuggle deep in your bed."

*Traditional German Lullaby*

# Champagne and Confetti

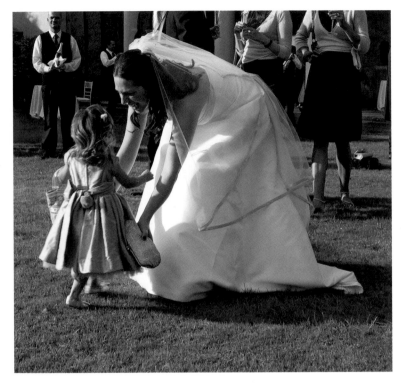

**Confetti is** the name for the candy-coated almonds that are tied in mesh bags and thrown at the bride and groom on their wedding day in Italy. The tradition of scattering confetti over newlyweds is used throughout the world, but what is traditionally thrown varies from country to country.

**What is your favourite pink item?** *A cashmere jacket*

**What is your favourite pink flower?** *A rose*

**What would the colour pink smell like?** *Like a champagne cocktail*

*Dame Judi Dench*

**England** – dried rose petals and shreds of coloured paper

**Iran** – crumbs thrown out of two sugared cones

**Korea** – red dates to symbolise fertility

**Lithuania** – grain and water to ensure wealth and bountiful harvests

**America** – rice to symbolise fertility

**Romania** – candy and nuts

**Germany** – the bride and groom throw coins for children waiting outside the church

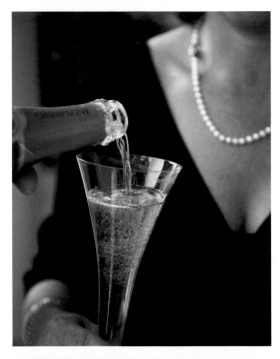

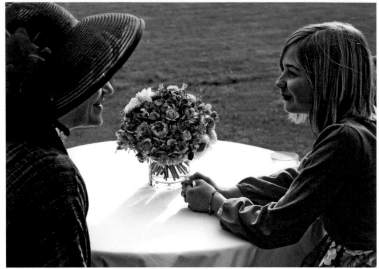

Pink can be found on the wine rack, from the delicate salmon pink Sancerre rosé to the deep crimson pinks of many New World wines. Blush wines were once drunk solely by women, and only during the summer months. Nowadays however, with a larger range of high quality rosés, they are being enjoyed by more people, more frequently; rosé wine is now drunk throughout the year both as an aperitif or with light foods such as seafood.

Pinot Noir makes a particularly good pink Champagne and rosé wine, being light bodied with good acid. Used in Sancerre rosé, Pinot Noir gives a light taste of freshly crushed strawberries. In the New World and sunny south of France, rich red grapes such as Grenache, Cinsault and Syrah are used. Particularly chic is the pretty pink Provence rosé, evocative of long lunches and the lazy sunshine of the region.

Most Champagne is made from a blend of Chardonnay and Pinot Noir, a red grape with a white juice. To create rosé Champagnes, rather than using solely the juice the skin of the Pinot Noir is left in contact for a short period of time to gently add a tinge of pink.

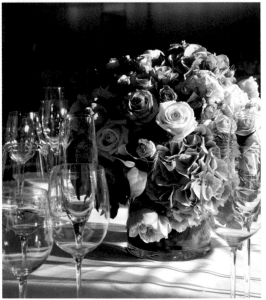

# *Here come the* **Boys**

**Pink can** be seen on the pitch too, with even the most masculine players sporting the colour. The French rugby team Stade Français play in a bright pink shirt, and the Maglia Rosa (or pink jersey) is awarded to the leader of the Giro d'Italia (Tour of Italy). A fluorescent pink ball has been used at Lord's cricket ground and footballers Franck Ribéry and Nicklas Bendtner have both been seen wearing pink boots.

**Many teams** have dressed in pink to show support for breast cancer awareness, from local clubs to internationally renowned teams. One such team is the Australian cricket team who donned pink shirts and bat grips in a match against South Africa to raise money for the McGrath foundation, a charity set up in honour of a cricketer's wife who died from breast cancer. Spectators were encouraged to wear pink, and the day, which used to be a ladies' day, will become a pink day from now on.

Nowadays, with many men embracing pink, the colour can be seen in ties, shirts and knitwear. Thomas Pink sell mens' and women's shirts, packaged in pink bags or giftwrapped in pink and black. Shirts can be made to order in their Personally Pink line, the PINK label stitched into the collar. The company was set up by three brothers and named after an 18th-Century tailor renowned for the red hunting jackets he made. If you were fortunate enough to own one of these sought-after jackets, you were said to be "in the pink".

When scanning the rows of newspapers and magazines in a newsagents the Financial Times jumps out in a flash of salmon pink. Since 1893 the newspaper has been printed in this distinctive shade for the very same reason, to make it stand out against competitive daily newspapers.

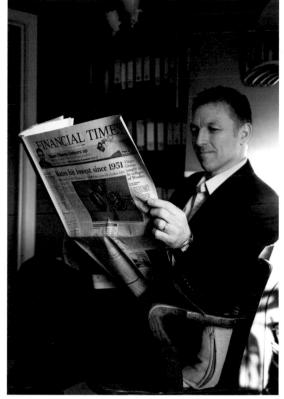

**What is your favourite pink item?** *A pink tie my wife gave me. It's a strawberry ice-cream kind of colour*

**What is your favourite shade of pink?** *The deep, orangey-pink of an English sunset*

**What would the colour pink smell like?** *Sweet and sugary*

*Geordie Greig*
*Editor Tatler*

# Sun, Sea and Sandcastles

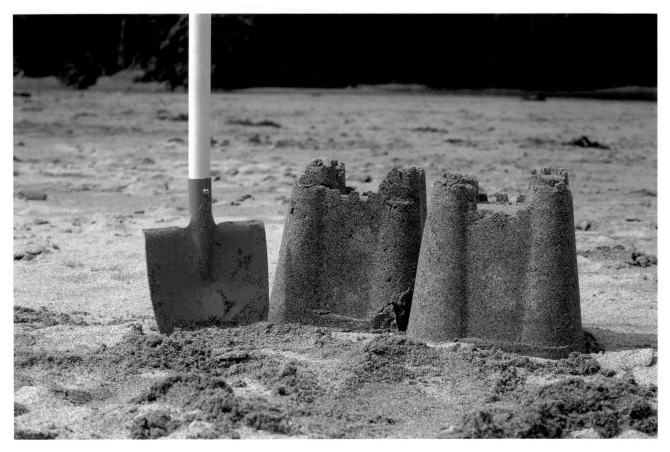

Digging and playing in the sand may be reminiscent of childhood summers, but building sandcastles isn't just for children. The National Sandcastle Competition takes place in Woolacombe every year, sand sculptures rising from the beach as teams from Britain and overseas compete in this famous competition.

Pink can be seen at the seaside in the form of buckets and spades, windbreaks, spotty swimming costumes and the beach itself. The Pink Beach Club is situated on the Bermuda shoreline, and the Pink Sands resort in the Bahamas boasts a 20-mile beach of gentle pink sand and pastel-shaded beach huts.

Imagine all that combined with a rich pink sun setting over the sea, and you have yourself a pink paradise.

# Make Mine Pink...

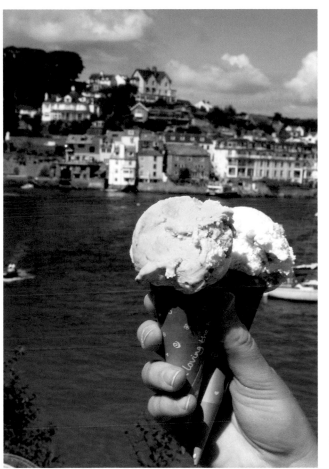

## Pink icecream flavours

Strawberries and Cream, Raspberry Ripple, Rhubarb, Rose, Watermelon, Pomegranate, Bohemian Raspberry, Strawberry Cheesecake, Rhubarb Crumble, Raspberry Pavlova, Pink Grapefruit, Summer Berries, Champagne and Strawberries

What is your favourite pink item? *My new Blackberry pearl*

What is your favourite pink flower? *Rosebuds*

What is your favourite shade of pink? *Hot pink*

*Rosie Mullender*
*Senior Features Writer*
*Cosmopolitan*

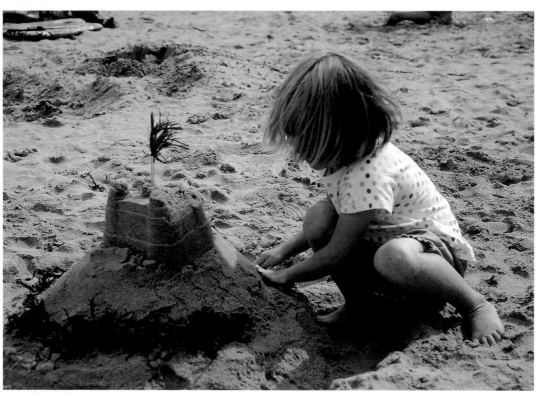

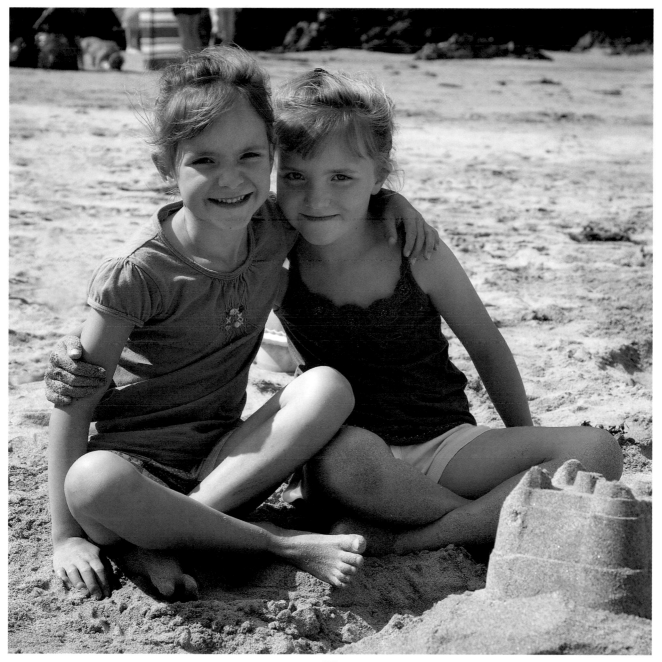

# Paint the Town Pink

Farrow & Ball may be best known for their deep, earthy tones and sophisticated whites, but their range of pink paints are equally as beautiful, from the mauve pink Cinder Rose, to the terracotta-tinted Ointment Pink. Joa Studholme, international colour consultant to Farrow & Ball, cites Middleton Pink as perhaps Farrow & Ball's most popular shade.

From the 1870s shades like Calamine were regularly used in country house anterooms and boudoirs. During Regency times strong pinks were used as a foil for architectural details such as columns.

Joa suggests that north-facing rooms benefit from being painted a warm shade of pink, unless they contain a brown or blue base. Rich pinks look particularly powerful in candlelight, so can be stunning in dining rooms and firelit libraries.

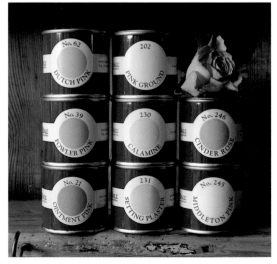

If you could paint anything pink what would you paint? *An inside of a cupboard or wardrobe*

What is your favourite pink paint? *Cinder Rose, Farrow & Ball*

*Kate French*
*Decorating Editor*
*Homes & Gardens*

# *Home Sweet Home*

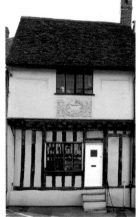

**Unpainted plaster** is very often thought of as pink, yet it has a distinctly yellow undertone. Interestingly, the word pink was once used to describe a quarried ochre pigment.

The medieval town of Lavenham in Suffolk is famous for its pink, timbered, higgledy-piggledy houses. In the high street, sitting amongst this rosiness is The Tickled Pink Tearoom.

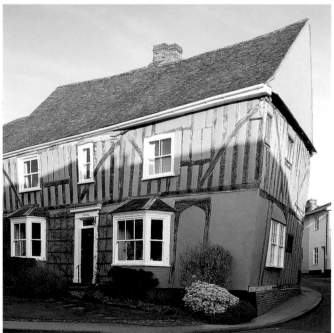

What is your favourite pink item? *A beautiful pink house on the Kennedy Coast*

What is your favourite pink flower? *A rose*

What is your favourite pink-coloured food? *Iced pink fairy cakes*

*Sarah Brown*
*Downing Street*

# *Minnie Mouse's* Kitchen

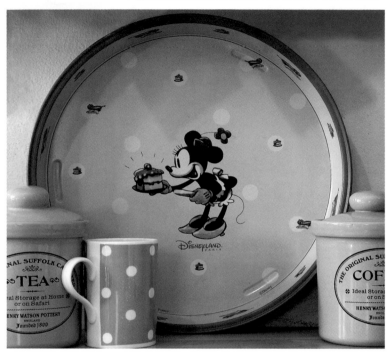

I visited Disneyland when I was younger and Minnie Mouse's kitchen was by far my favourite attraction, from the pink cooker to the dusting of hearts and polka dots. Sarah Otten has a similar love for pink, owning the gorgeous pink Aga on the opposite page. Her husband, an understanding man, allows her to have one pink room in the house and she chose the kitchen. When the new Aga arrived, her husband remarked: "That's not a cream Aga!"

Pink has also been popular in the kitchens of chefs, with many pink recipes cropping up in cook books. Nigella Lawson's spiced pink soup is based on beetroot with cumin, coriander and sour cream, whereas Delia Smith's Thai bean salad contains pink grapefruit and grapes. Pink can even be seen in Gordon Ramsay's recipes, with his new season pink lamb served with crushed peas.

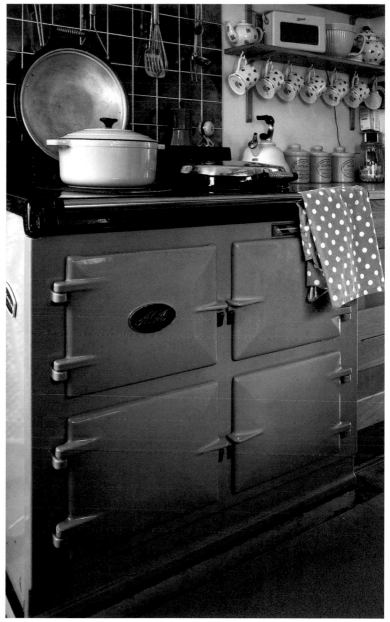

What is your favourite shade of pink?
*Fuchsia — really bright!*

What would the colour pink smell like? *Candy floss*

*Marie Nichols*
*Deputy Style Editor*
*Ideal Home*

This beautiful pink Aga is a different shade to those you would find in a show room, as the colour darkens when the Aga warms up

# Head Girl's Office

Colour is an essential part of learning and revision, from colour-coded files to fluorescent pink highlighters. For visual learners using colour helps to recall information more effectively. Colour also engages different parts of your brain so helps you to learn and remember information. Pink highlighters may be particularly popular as they are bright enough to emphasize important information, whilst being less harsh and strong than red.

For some people, colour is used subconsciously to visualise information. Colour synaesthesia is the name of a phenomenon in which a person relates words and numbers to specific colours.

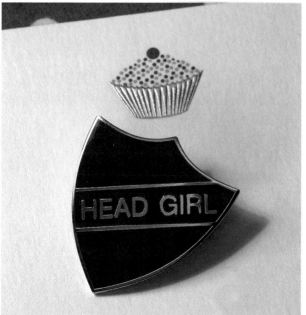

**What is your favourite shade of pink?** *I love all pinks, especially an almost grey pale pink – nearly lavender. I also love very bold magenta and fuchsia*

**If you could paint any room pink what would it be?** *My home office – and I would have a white desk, chair and shelves, a pink laptop and lots of roses*

*Isobel McKenzie-Price*
*Editorial Director Ideal Home*

# *And so to* **Bed...**

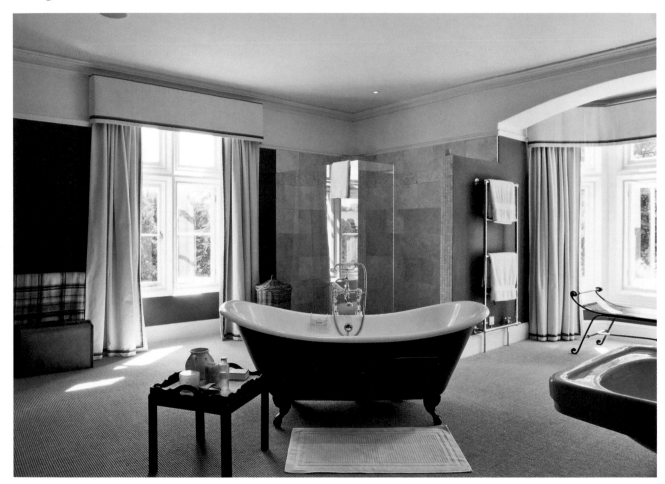

**The sumptuous** bed on the opposite page lives at the Schiaparelli Suite in The May Fair Hotel, London.

Elsa Schiaparelli was an Italian fashion designer working between the two world wars, who invented the shade Shocking Pink (also know as Schiaparelli Pink, or Hot Pink in America). This shade that flits between fuchsia and magenta was inspired by a Cartier pink diamond and appeared on the box of Schiaparelli's first perfume. The fragrance was named Shocking and so the colour was christened.

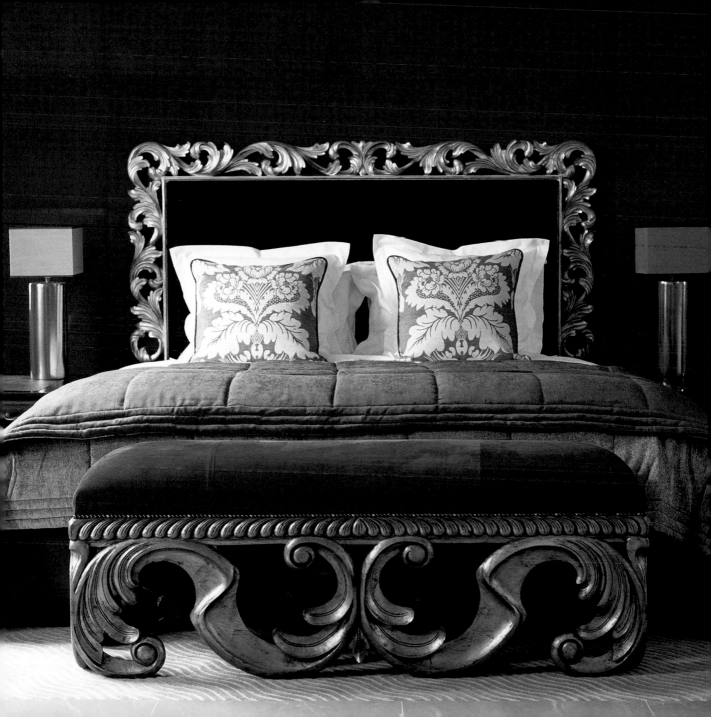

# I'm Dreaming of a Pink Christmas

## A Pink Christmas List

Asprey's pink diamond ring
A pink Aga
A field of pink tulips
Sunset over a Maldivian Island
A pink private jet
A pink champagne fountain
A lifetime's supply of cupcakes
An orchard of cherry blossom trees
Penelope Pitstop's pink car
A pink castle

Merry Christmas *Joyeux Noël* Froehliche Weihnachten *Feliz Navidad* Nadolig
Llawen *God Jul* Feliz Natal *Buon Natale* Frolijk Kerstfeest *Hyvää Joulua*
Sretan Božic *Selamat Hari Natal* Veselé *Vánoce* Maligayang *Pasko*

# *Libby's Favourites*

**What is your favourite pink item?** *Pink plastic Vivienne Westwood shoes!*

**What is your favourite pink flower?** *Foxgloves and gerbera*

**What would the colour pink smell like?** *Cupcakes and Coco Mademoiselle*

**What is your favourite shade of pink?** *Blush pink or eye-popping pink*

**If the colour pink was a place, what place would it be?** *Heaven!*

I hope this book will raise some money for breast cancer care
Fanahan Books will be donating 70% of the profit from this book to breast cancer care

And a big thank you to everyone who replied to my questionnaire!
All job titles were correct when going to print – apologies if any have changed

Detail from The Three Graces by Antonio Canova

# Acknowledgements

**Pg 1.** Pretty knickers provided by Mee, Bartlett Street, Bath
www.meeboutique.com

**Pg 3.** Mannequin of flowers created by Rachel Lilley, Rachel Lilley Flowers, Walcot Street, Bath
www.rachellilley.com

**Pg 4.** Ballet shoes photo with thanks to Ted Martin of Ted Martin Flowers

**Pg 6.** Thank you to Freddie Eyre for modelling and to Camilla Scott-Bowden for lending us her Venetian mask

**Pg 7.** Photo of vintage Balenciaga coat from V&A Images/Victoria and Albert Museum

**Pgs 10 – 14.** With thanks to Susan North of the Victoria and Albert museum for her time, knowledge and encouragement
Images: V&A Images/Victoria and Albert Museum

**Pgs 15 – 19.** Thank you to Andrew Hansford of the Travilla Estate for all his help and to the Fashion Museum of Bath for their kind co-operation
Photo of Marilyn Monroe with William Travilla and William Travilla sketch reproduced courtesy of the Travilla Estate

**Pg 20.** Photograph of Marilyn Monroe courtesy of Twentieth Century Fox

**Pg 21.** Thanks to Christopher Macdonald, Asprey London Ltd, 167 New Bond Street, London, W1S 4AY
www.asprey.com

**Pg 22 – 25.** Thank you to Niki Fretwell for her help with Vintage Pink and for the use of her photographs.
www.nostalgia-stonehouse.co.uk

**Pg 26 – 28.** Thank you to Alice Temperley, 6 – 10 Colville Mews, Lonsdale Road,

London, W11 2DA
www.temperleylondon.com

**Pg 29 – 31.** Thank you to Matthew Williamson, 28 Bruton Street, London W1J 6QH
www.matthewwilliamson.com

**Pg 32.** Shoe shop featured: Buffalo, Dublin
www.buffalo-boots.com

**Pg 33.** Thank you to Georgia Oliver for modelling on a freezing day in December and to Mee, Bartlett Street, Bath
www.meeboutique.com

Bags provided by:
PrintLab International Limited, Ireland
+ 353 86 2520278
Keepme Promotions, Greenhithe, Kent.
www.keepmepromotions.com
Duo Shoes, Bath
www.duoshoes.co.uk

**Pg 34.** Thank you to Mulberry for the photo of their gorgeous Ostrich Fuchsia Bayswater bag
www.mulberry.com

**Pg 35.** Bag made by the very talented Harriet Rose of Harriet Rose Handbags

**Pg 36.** Thank you to our lovely models Sally and Eva

**Pg 37.** Thank you to Pippa Bell for the loan of her fabulous pink shoes and Monty Don earrings

**Pg 40 – 41.** Thank you to the Blushing Belles Bee Hillier, Freddie Eyre and Janaissa Eaglestone and to Gay Jose for the use of her house

**Pg 44.** Thanks to Annabel Lewis of V.V. Rouleaux
www.vvrouleaux.com

**Page 45.** Thanks to Macculloch Wallis
www.macculloch-wallis.co.uk

**Pg 46 – 47.** Many thanks to Bijoux Beads of Bath, Salisbury and Shaftesbury
www.bijouxbeads.co.uk

**Pg 48 – 49.** Thank you very much to Sunita Patel for making us so welcome
Taste of India
01400273133

**Pg 50 – 51.** Thank you to Suzanne & Angela of Cranch's The Original Sweet Shop, Salcombe, Devon

**Pg 52.** Thank you to Dan and his kitten!

**Pg 53.** Candy generously provided by The Original Candy Co Ltd, Fairford, Gloucestershire
www.originalcandyco.com

**Pg 54 – 55.** Thank you to David Austin and Martyn & Gay Jose for providing pink gardens
www.davidaustinroses.com And thanks to Brad
www.bradleysthetannery.co.uk

**Pg 56 – 57.** Thank you to our beautiful Flower Fairies, Molly & May Hughes

**Pg 59.** Thank you to Natalie Hughes for letting us cover her hair in flowers

**Pg 62 – 64.** Thank you to Nikki of Country Cupcakes, Walcott Street, Bath, for providing delicious cupcakes for us to photograph (and eat)
www.countrycupcakes.com

**Pg 64.** Thank you to all our friends who let their teddies come on our teddy bears' picnic

**Pg 65 – 67.** Thank you to sweet and sleepy Molly McLaughlin

**Pg 68 – 71.** Thank you to Jo & Gabriel McLaughlin for letting us feature your wedding
Silk coat modelled by Camilla Scott-Bowden and provided by Charlie Rollo-Walker
www.arightcharlie.com
Wine information provided by wine consultant Grant Page (Thank you, Dad!)

**Pg 72 – 75.** Thank you to our men in pink Martyn Morecroft, Max Braddick, Mikey Phillips, Finn Hughes, Ruairi Bell, Fergus Bell and Tim Wood

**Pg 78 – 79.** Thank you to our lovely Salcombe beach babes Francesca, Alice, Emily and Lucy

**Pg 80 – 81.** Thank you to Farrow & Ball for all their help
www.farrow-ball.com

And to their international colour consultant, Joa Studholme, for her time and insights

**Pg 85.** Thank you to Sarah Otten for letting us invade her pink kitchen to photograph her Aga

**Pg 86 – 87.** Pink stationery provided courtesy of Smythson of Bond Street
www.smythson.com

**Pg 88.** Photo of pink bathroom generously provided by photographer Andy Pini, 4 Florence Street London, N4 4BU
07721 431222          www.andypini.com

**Pg 89.** Photo of bedroom provided by The May Fair Hotel, London
www.themayfairhotel.com

**Pg 90 – 91.** Thank you to Carol Ridler for her gorgeous wooden Christmas decorations
www.handcraftedwood.co.uk
And to Annie Hughes for letting us photograph in her house

**Back Cover.** Pink fairy: Saoirse Keys, Auckland

Also published by Fanahan Books:

THE FLOWER SHOP

A YEAR IN THE LIFE OF AN ENGLISH COUNTRY FLOWER SHOP

By Sally Page

THE FLOWER SHOP
*Christmas*

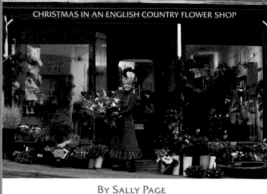

CHRISTMAS IN AN ENGLISH COUNTRY FLOWER SHOP

By Sally Page

FLOWER SHOPS
*& friends*

A YEAR'S JOURNEY AROUND ENGLISH FLOWER SHOPS

By Sally Page

FLOWER SHOP
*Secrets*

By Sally Page

For full details visit:
www.fanahanbooks.com